Left Hand Writin

An Art 101 Book

 ## 2nd - Edition

Modified:

Neat Font

Added:

Dance Font

New line-arts

- Trace letters and words,
- Learn line-arts
- Enjoy stories and riddles

The foundation of an artistic & creative mind

ISBN: 978-1729429396, Copyright © 2018 Derek Schuger, derekschuger@gmail.com

(Neat font)

Handwriting is an artistic skill.

Learn it by tracing these figures.

(Dance font)

Drawing reflects creative mind

Cultivate it by tracing these figures.

Table of Contents

 Write your name above the line.

How to draw apples? Let's trace.

Trace and write letter A and a.

Ａ Ａ Ａ Ａ Ａ Ａ Ａ Ａ Ａ

ａ ａ ａ ａ ａ a ａ ａ

 What day is today? Circle one.

Sunday

Monday

Tuesday

Wednesday

Thursday

Friday

Saturday

Sweet And Sour Apples

Lily had a smaller apple. Tommy had a bigger apple.

Lily took a bite of her samller apple. Sweet! Lily smiled.

Tommy took a bite of his bigger apple. Ouch! Sour!

It was so sour that one of Tommy's teeth fell out. He cried.

Please trace this funny story.

Lily had a smaller apple.

Tommy had a bigger apple.

Lily took a bite of her samller

apple. Sweet! Lily smiled.

Tommy took a bite of his bigger

apple. Ouch! Sour!

It was so sour that one of

Tommy's teeth fell out. He cried.

Continued on the next page.

 Write your name above the line.

Lily said, "Don't cry. Put the tooth under your pillow.
The tooth fairy may give you a dollar."

Let's continue to trace.

How to draw crying Tommy and laughing Lily? Let's trace.

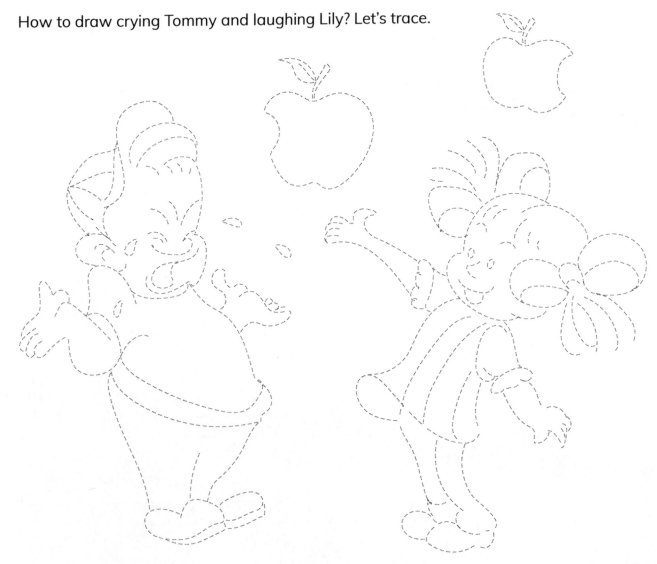

 What day is today? Circle one.

 Sunday Monday Tuesday Wednesday Thursday Friday Saturday

How to draw a bear with ear ring? Let's trace.

Trace and write letter B and b.

 Write your name above the line.

The Bear Has No Ears

What do you call a bear that has no ears?

Think about what if the letters "ear" are removed from the word "bear".

The answer is on the next page.

Please trace the following words.

What do you call a bear that
has no ear?
Think about what if the letters
"ear" are removed from the word
"bear".
The answer is on the next page.

 What day is today? Circle one.

 Sunday Monday Tuesday Wednesday Thursday Friday Saturday

Let's trace the answer.

The answer is letter "b".

Please rewrite the above answer in the following space.

How to draw polar bears? Let's trace.

 Write your name above the line.

How to draw a cat? Let's trace.

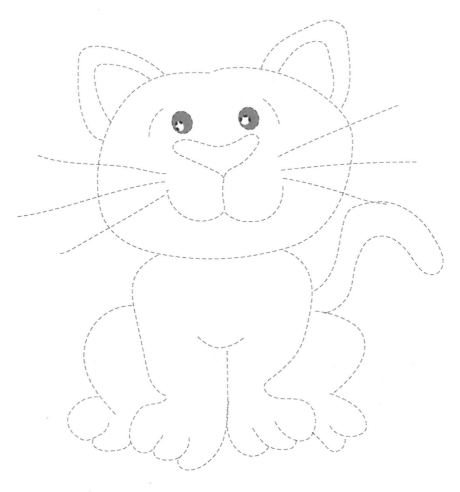

Trace and write letter C and c:

 What day is today? Circle one.

Sunday Monday Tuesday Wednesday Thursday Friday Saturday

Amelia's Cat

Amelia is a pretty girl and she has a cat. The cat's name is Kitty.

One of Amelia's best friends is Katherine. They call her Katy, not Kitty.

Let's trace the story.

Amelia is a pretty girl and she
has a cat. The cat's name is Kitty.
One of Amelia's best friends is
Katherine. They call her Katy, not
Kitty.

 Write your name above the line.

How to draw a girl? Let's trace Amelia.

 What day is today? Circle one.

Sunday Monday Tuesday Wednesday Thursday Friday Saturday

How to draw a dog? Let's trace.

Trace and write letter D and d:

D D D D D D D D

d d d d d d d d

 Write your name above the line.

Jack's Dog

Jack is a handsome boy and he has a dog.

One of Jack's best friends is Bobbie. They call him Bobbie, not Puppy.

Please trace this funny story.

Jack is a handsome boy and he

has a dog.

One of Jack's best friends is

Bobbie. They call him Bobbie, not

Puppy.

 What day is today? Circle one.

 Sunday Monday Tuesday Wednesday Thursday Friday Saturday

How to draw a cute dog? Let's trace.

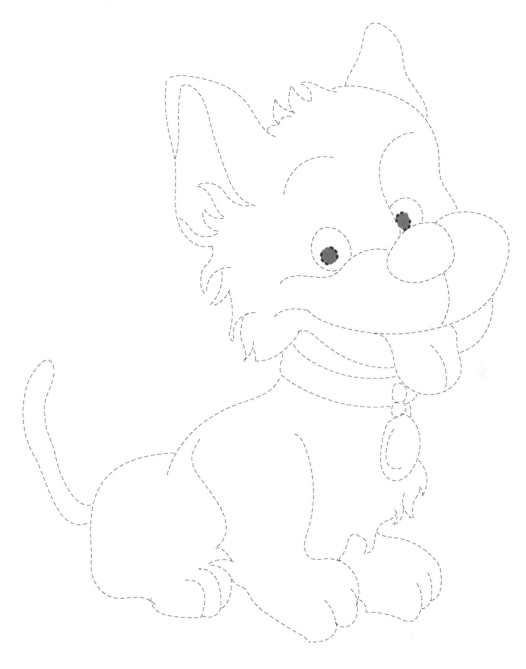

 Write your name above the line.

How to draw a cute elephant? Let's trace.

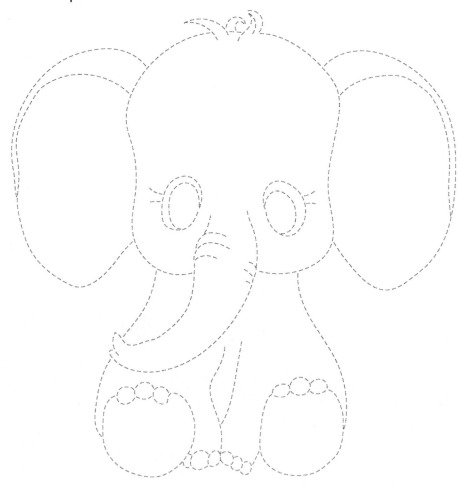

Trace and write letter E and e:

16 § How to draw a cute elephant?

 What day is today? Circle one.

Sunday Monday Tuesday Wednesday Thursday Friday Saturday

Elephant And Pinocchio (Part 1)

In the zoo, Jessica finally saw the real elephant for the first time. They all have long noses.

"They are bad animals!" she pointed at the elephants.

"Why?" daddy asked.

"They must have lied too much, because they all have long nose."

Let's trace the story.

In the zoo, Jessica finally saw
the real elephant for the first
time. They all have long noses.
"They are bad animals!" she
pointed at the elephants.
"Why?" daddy asked.
"They must have lied too much,
because they all have long nose."

Continued on the next page.

 Write your name above the line.

Elephant And Pinocchio (Part 2)

"How do you know?"

"Because Pinocchio's nose grew longer when he lied."

"Oh! Good thought," daddy said.

Let's continue to trace.

How to draw a elephant? Let's trace.

 What day is today? Circle one.

Sunday Monday Tuesday Wednesday Thursday Friday Saturday

How to draw a fish? Let's trace.

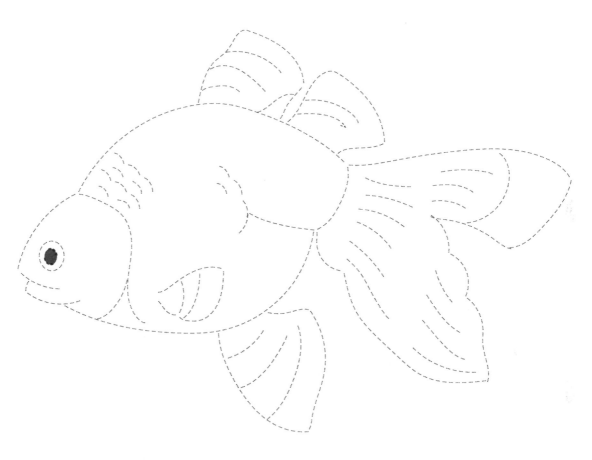

Trace and write letter F and f:

 Write your name above the line.

Where is the fish from?

Where does the fish live?
In water.
Where do we live?
On the land.
What do you do if you want to have some fish?
Ask mom to buy fish from a fish store.
Who bring the fish from the water to the store?
Fishermen.

Please trace the following words.

Where does the fish live?

In water.

Where do we live?

On the land.

What do you do if you want to

have some fish?

 What day is today? Circle one.

Sunday

Monday

Tuesday

Wednesday

Thursday

Friday

Saturday

Please trace the following words.

Ask mom to buy fish from a fish
store.
Who bring the fish from the
water to the store?
Fishermen.

Let's trace a bubble fish:

 Write your name above the line.

How to draw a giraffe?
Let's trace it.

Trace and write letter G and g:

 What day is today? Circle one.

Sunday

Monday

Tuesday

Wednesday

Thursday

Friday

Saturday

The Tallest Animal In The World (Part 1)

In the zoo, Oliver saw giraffes for the first time.

"The giraffe is the tallest animal in the world," daddy said.

"Really! why?"

"Because they all have long necks. You see!"

"But crane has long neck too, daddy?"

"Oh... Probably not as long as the giraffes'," daddy said.

Let's trace the story.

In the zoo, Oliver saw giraffes
for the first time.
"The giraffe is the tallest
animal in the world," daddy said.
"Really! why?"

Continued on the next page.

Write your name above the line.

The Tallest Animal In The World (Part2)

Let's trace.

"Because they all have long

necks. You see."

"But crane has long neck too,

daddy?"

"Oh... Probably not as long as

the giraffes." daddy said.

Let's drawing more fish jumping out off water.

 What day is today? Circle one.

| Sunday | Monday | Tuesday | Wednesday | Thursday | Friday | Saturday |

How to draw a horse? Let's trace.

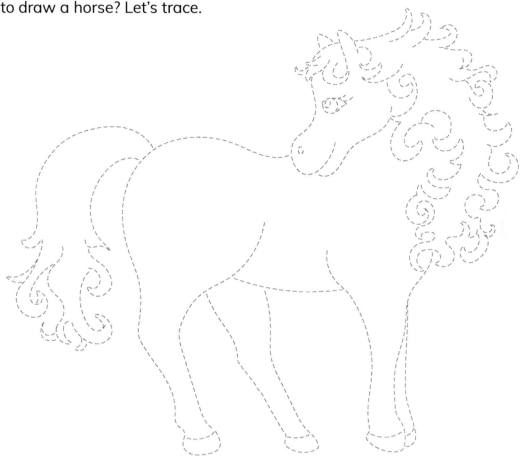

Trace and write letter H and h:

Write your name above the line.

Unicorn, Pegasus And Horse

The unicorn has horn; the Pegasus has wings; and they all have horse bodies.

Why?

Our imagination let the horse have a horn to be the unicorn; and let the horse have wings to be a Pegasus.

Imagination is powerful; imagination is fun.

Let's trace the story.

The unicorn has horn; the
Pegasus has wings; and they all
have horse bodies.
Why?
Our imagination let the horse
have a horn to be the unicorn; and
let the horse have wings to be a

Continued on the next page.

 What day is today? Circle one.

| 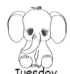 | | | | | | |
| Sunday | Monday | Tuesday | Wednesday | Thursday | Friday | Saturday |

Pegasus.

Imagination is powerful,

imagination is fun.

How to draw a unicorn? Let's trace.

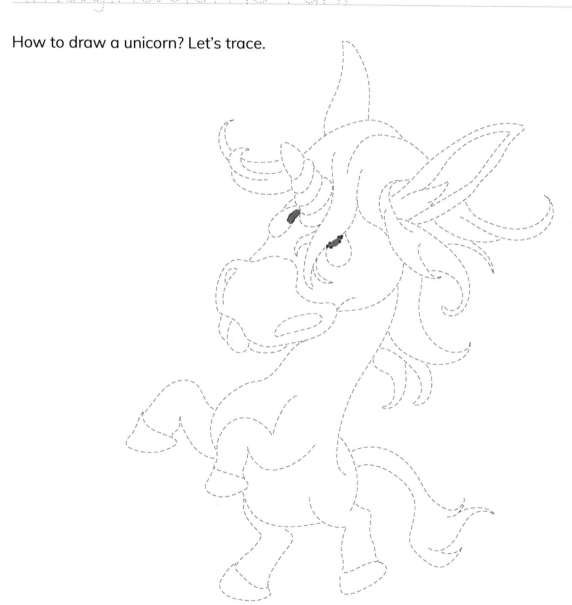

 Write your name above the line.

How to draw a big ice cream? Let's trace.

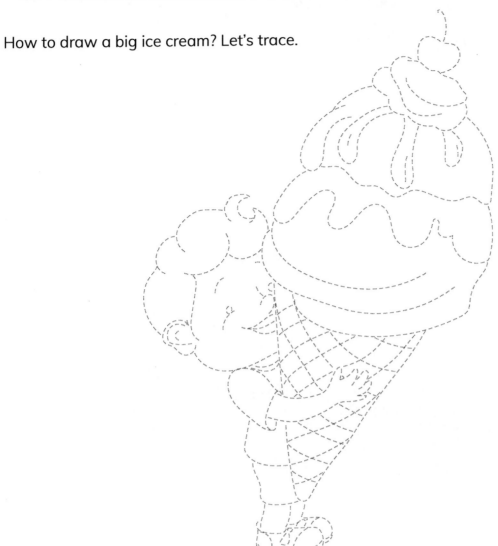

Trace and write letter I and i.

 What day is today? Circle one.

Sunday

Monday

Tuesday

Wednesday

Thursday

Friday

Saturday

Play House (Part 1)

"Would you like some ice cream?" Ava asked.

"Yay!" Charlie was excited.

Let's trace the story.

"Would you like some ice cream?" Ava asked. "Yay!" Charlie was excited.

 Write your name above the line.

Play House (Part 2)

Ava put an empty plate in front of Charlie, "Here you are."

"...?"

"We are playing House."

Let's continue to trace the Playing House.

Let's draw a unicorn by tracing it.

 What day is today? Circle one.

Sunday

Monday

Tuesday

Wednesday

Thursday

Friday

Saturday

How to draw a jumping boy? Let's trace.

Trace and write letter J and j.

 Write your name above the line.

Dog Didn't Jump

I jumped, you jumped and everybody jumped.

Ruby's dog didn't jump because Ruby's dog didn't understand the sound, "Jump!"

But it barked when saw everyone jumping.

Let's trace the story.

I jumped, you jumped and

everybody jumped.

Ruby's dog didn't jump because

Ruby's dog didn't understand the

sound, "Jump!"

But it barked when saw

everyone jumping.

 What day is today? Circle one.

Sunday Monday Tuesday Wednesday Thursday Friday Saturday

Let's learn how to draw happy and unhappy dogs by tracing them.

 Write your name above the line.

How to draw kangaroo and her baby? Let's trace.

Trace and write letter K and k.

 What day is today? Circle one.

Sunday Monday Tuesday Wednesday Thursday Friday Saturday

Run Or Hop

How fast can the Kangaroo run?

Kangaroos don't run, they hop.

Kangaroos can hop very fast.

Let's trace the story.

How fast can the Kangaroo
run?
Kangaroos don't run, they hop.
Kangaroos can hop very fast.

 Write your name above the line.

Let's learn how to draw cats by tracing them.

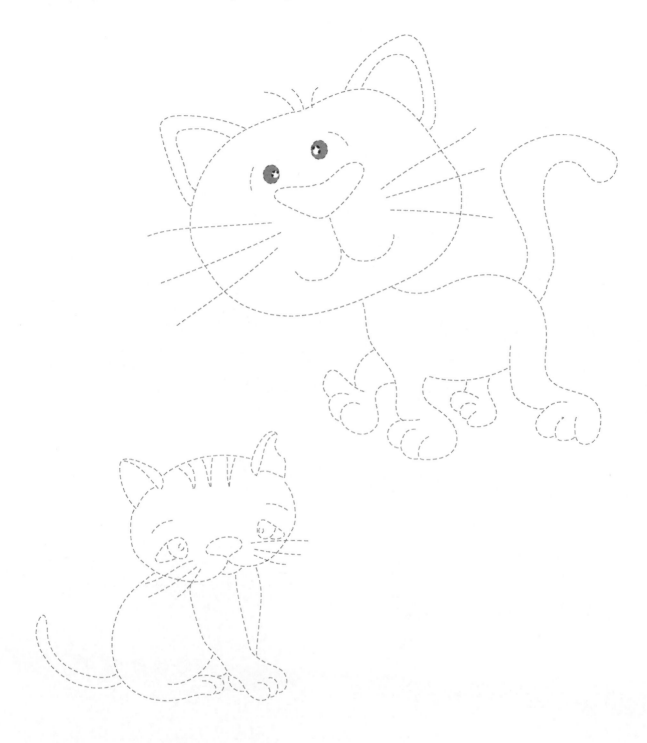

 What day is today? Circle one.

Sunday　Monday　Tuesday　Wednesday　Thursday　Friday　Saturday

Let's learn how to draw a mad elephant.

Trace and write letter L and I.

 Write your name above the line.

Numbers And Math

What is number?

Number is 1, 2, 3, 4, 5, 6, 7, 8, 9, 0.

What is math?

Math is how to play with the numbers, like 2 + 3 = 5

Trace the words and numbers.

Let's draw ten fish. Trace them.

 What day is today? Circle one.

 Sunday

 Monday

 Tuesday

Wednesday

Thursday

 Friday

 Saturday

Write Numbers Neatly!

Trace the numbers and do some math.

1

2

3

4

5

1 + 1 = 2 1 + 2 = 3 2 + 3 = 5

5 - 3 = 2 4 - 1 = 3 3 - 1 = 2

5 - 1 = 4 3 - 2 = 1 4 + 1 = 5

Write your name above the line.

How to draw a hanging monkey?
Let's trace.

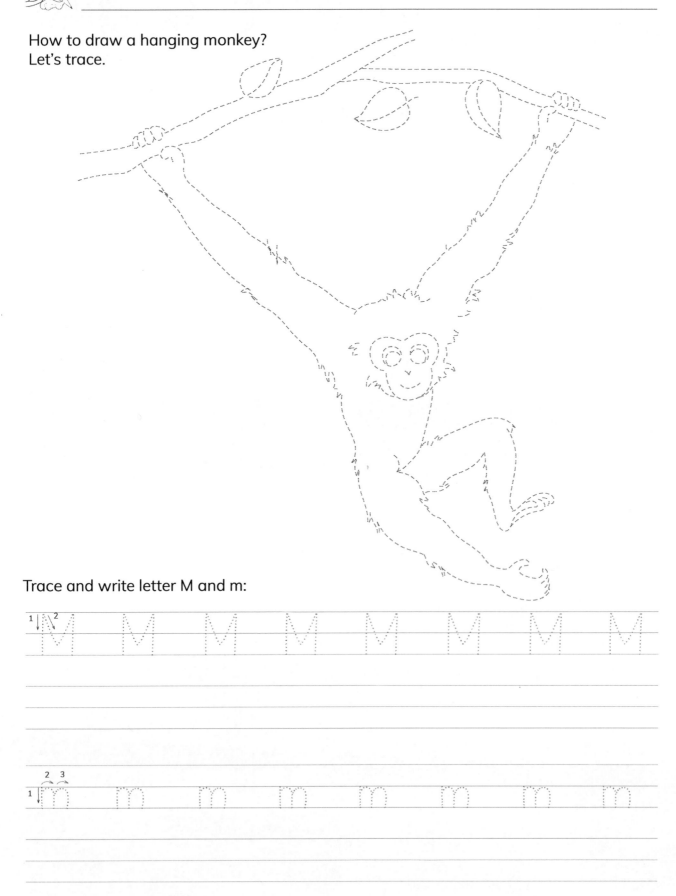

Trace and write letter M and m:

M M M M M M M M M

m m m m m m m m

 What day is today? Circle one.

Sunday Monday Tuesday Wednesday Thursday Friday Saturday

Write Numbers Neatly!

Trace the numbers and do some math.

6 6 6 6 6 6 6 6

7 7 7 7 7 7 7 7

8 8 8 8 8 8 8 8

9 9 9 9 9 9 9 9

0 0 0 0 0 0 0 0

$$7 + 1 = 8 \qquad 5 + 4 = 9 \qquad 2 + 6 = 8$$

$$9 - 4 = 5 \qquad 8 - 1 = 7 \qquad 2 - 2 = 0$$

$$8 - 6 = 2 \qquad 4 - 1 = 3 \qquad 9 + 9 = 18$$

 Write your name above the line.

Addition And Subtraction

The addition is adding a number to another, like 1 + 3 = 4.
Subtraction is removing a number from a number, like 3 - 1 = 2.

Trace to know.

The addition is adding a number
to another, like 1 + 3 = 4.
Subtraction is removing a
number from a number, like
3 - 1 = 2.

Let's count your fingers.

2 + 3 = ☐

$\begin{array}{r} 2 \\ + 3 \\ \hline \end{array}$ ☐

What day is today? Circle one.

Sunday Monday Tuesday Wednesday Thursday Friday Saturday

Let's trace a surprised doggie.

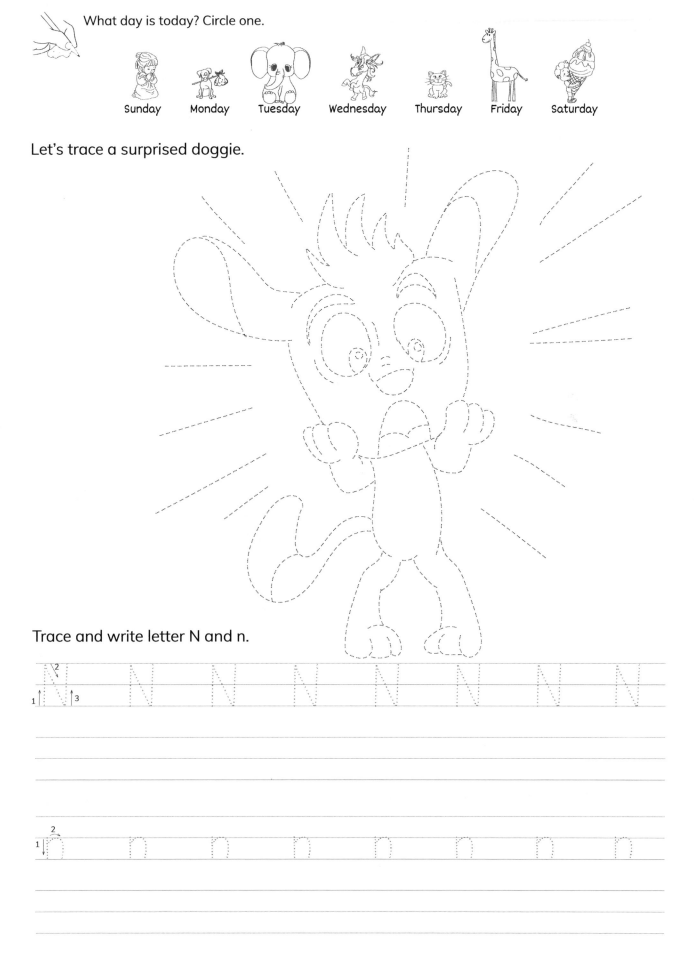

Trace and write letter N and n.

 Write your name above the line.

Math is an art!

Trace the numbers and write the numbers.

1 2 3 4 5 6 7 8 9 0

1 2 3 4 5 6 7 8 9 0

Trace the questions and solve the problems.

$7 + 2 =$ $4 + 4 =$ $2 + 5 =$

$8 - 4 =$ $8 - 1 =$ $2 - 2 =$

How to draw a school bus? Let's trace.

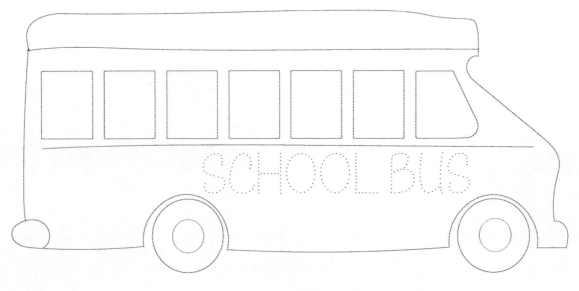

 What day is today? Circle one.

Sunday

Monday

Tuesday

Wednesday

Thursday

Friday

Saturday

School Bus

Sophie rode school bus to school; she rode school bus after school. Her mom drove her to school, and picked her up at school every day.

Why?

Sophie's mom was the bus driver.

Let's trace the story.

Sophie rode school bus to

school; she rode school bus after

school. Her mom drove her to

school, and picked her up at school

every day.

Why?

Sophie's mom was the bus

driver.

 Write your name above the line.

How to draw a girl? Let's trace.

Trace and write letter O and o:

Ο Ο Ο Ο Ο Ο Ο Ο

o o o o o o o o

46 § How to draw a Oh! Beautiful?

 What day is today? Circle one.

Sunday

Monday

Tuesday

Wednesday

Thursday

Friday

Saturday

Numbers are the smartest thing!

Trace the numbers and write the numbers.

1 2 3 4 5 6 7 8 9 0

1 2 3 4 5 6 7 8 9 0

Trace the questions and solve the problems.

8 + 2 = 4 + 6 = 5 + 5 =

8 − 8 = 8 − 6 = 9 − 7 =

 Write your name above the line.

Build A House At South Pole

Imagine if you could build a house on the south pole. All walls would face north, wouldn't?

By the way, do you know who lives at south pole?

Let's trace the question.

Imagine if you could build a
house on the south pole. All walls
would face north, wouldn't?
By the way, do you know who
lives at south pole?

Write your answer in the following space.

 What day is today? Circle one.

Sunday　Monday　Tuesday　Wednesday　Thursday　Friday　Saturday

Let's draw a praying girl.

Trace and write letter P and p:

P P P P P P P P

P P P P P P P P

 Write your name above the line.

Math = Smart!

Trace the numbers and write the numbers.

1 2 3 4 5 6 7 8 9 0

1 2 3 4 5 6 7 8 9 0

How to draw a panda?
Let's trace.

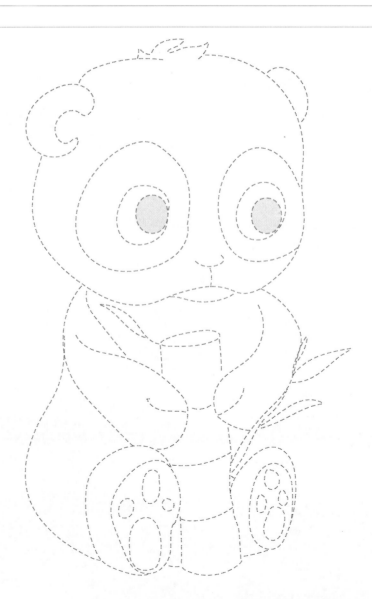

 What day is today? Circle one.

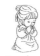 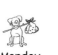 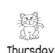

Sunday Monday Tuesday Wednesday Thursday Friday Saturday

Math Never Lie!

Trace the questions and answer them.

$8 + 2 =$ $6 + 4 =$ $5 + 5 =$

$18 - 4 =$ $16 - 1 =$ $17 - 6 =$

$17 + 2 =$ $14 + 4 =$ $12 + 5 =$

$12 - 4 =$ $18 - 9 =$ $15 - 6 =$

$7 + 4 =$ $4 + 7 =$ $2 + 9 =$

$12 - 4 =$ $14 - 5 =$ $16 - 7 =$

$7 + 7 =$ $8 + 8 =$ $9 + 9 =$

$23 - 11 =$ $41 - 3 =$ $21 - 2 =$

Fisherman

How to draw a fisherman who is fishing? Let's trace.

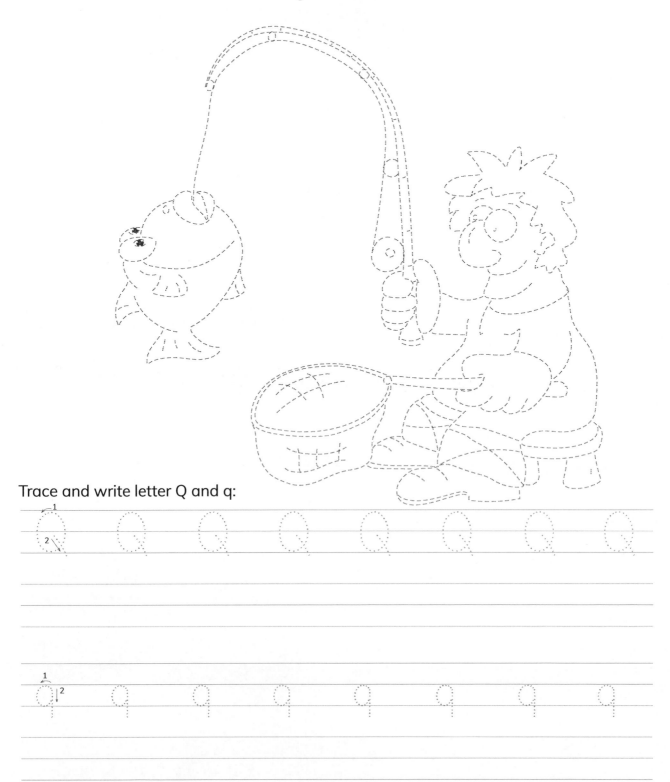

Trace and write letter Q and q:

52 § How to draw a fisherman who is fishing?

Sunday Monday Tuesday Wednesday Thursday Friday Saturday

What's a riddle?

What's a riddle? A challenging question to prove you're smarter if you know the answer.

For example, do you know a thing that has to be broken before you eat it?

The answer is the egg that you have to break the shell first.

Let's trace.

What's a riddle? A challenging question to prove you're smarter if you know the answer.

For example, do you know a thing that has to be broken before you eat it?

The answer is the egg that you have to break the shell first.

Write your name above the line.

Something In The Sky

Can you think of something up in the sky, that come out without being called at night, and disappear without being sent away in the day. What are they?

Let's trace the riddle.

Can you think of something up in
the sky, that come out without
being called at night, and
disappear without being sent away
in the day. What are they?

Stars come out at night and disappear in the day. The answer is the stars.

Let's trace the answer.

Stars come out at night and
disappear in the day. The answer
is the stars.

 What day is today? Circle one.

Sunday

Monday

Tuesday

Wednesday

Thursday

Friday

Saturday

How to draw a smart dog? Let's trace.

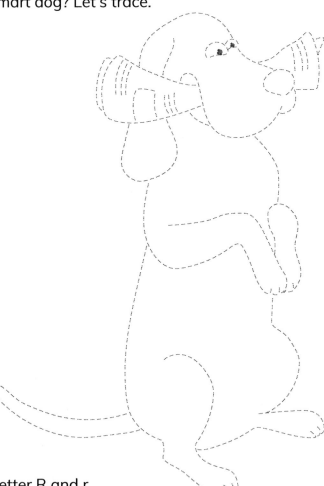

Trace and write letter R and r.

R R R R R R R R

r r r r r r r r

 Write your name above the line.

Two Mothers And Two Daughters

Two (2) mothers and two (2) daughters went to enjoy donuts, everyone ate one donut, and three (3) donuts were eaten in all. Do you know why?

Let's trace the riddle.

Two (2) mothers and two (2)
daughters went to enjoy donuts,
everyone ate one donut, and three
(3) donuts were eaten in all. Do you
know why?

Write your answer in the following space.

 What day is today? Circle one.

Sunday Monday Tuesday Wednesday Thursday Friday Saturday

Let's trace the answer.

The answer is that they were a grandmother, mother and daughter, total 3 persons.

Let's trace a flying witch's grandmother.

How to draw a flying witch's grandmother? § 57

 Write your name above the line.

How to draw a swan? Let's trace.

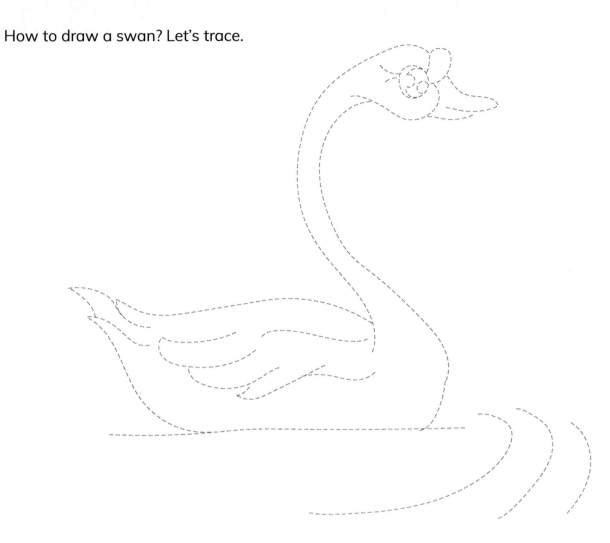

Trace and write letter S and s:

 What day is today? Circle one.

Sunday Monday Tuesday Wednesday Thursday Friday Saturday

Light It Up!

Tommy's dad walked into the log cabin, holding a book of matches. There was no electricity in the cabin and he needed to light a kerosene, a lamp, couple of candles and the fire place in the room. Which did he light the first?

Let's trace the riddle.

Tommy's dad walked into the

log cabin, holding a book of

matches. There was no electricity

in the cabin and he needed to light

a kerosene, a lamp, couple of

candles and the fire place in the

room. Which did he light the first?

Find the answer on the next

page.

 Write your name above the line.

Here is the answer. Let's trace.

Tommy's dad needed to light up
the the matches first.

Please rewrite the answer in the following space.

How to draw a cute dog?
Let's trace.

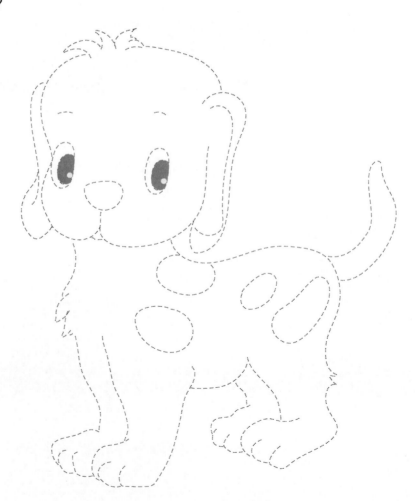

What day is today? Circle one.

Sunday Monday Tuesday Wednesday Thursday Friday Saturday

How to draw a teacup?
Let's trace.

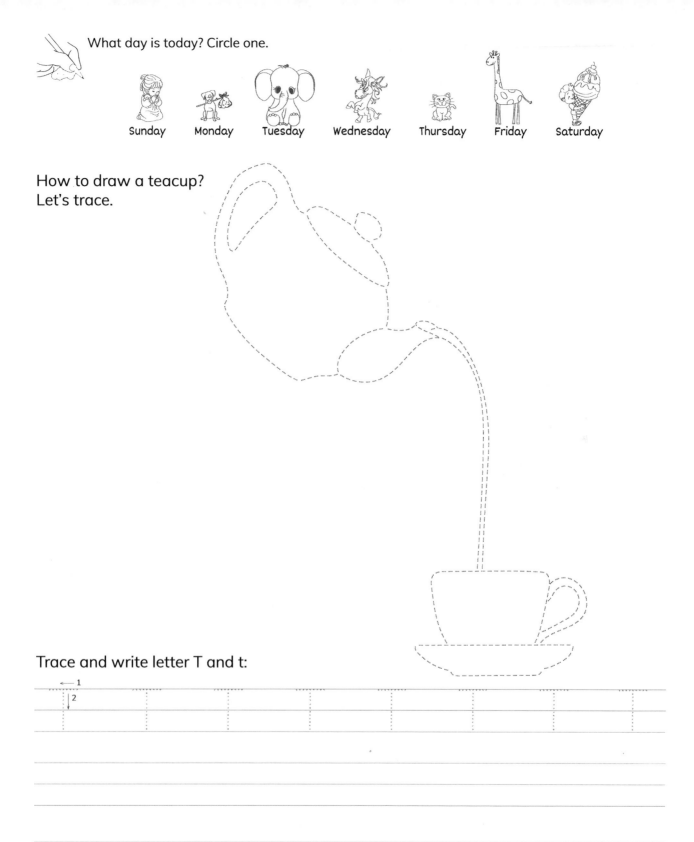

Trace and write letter T and t:

 Write your name above the line.

Letter "T"

Guess a thing. Its name starts with a "t" and ends with a "t". It is filled with "t". What is it?

Find the answer on the next page.

Let's trace the riddle.

Guess a thing. Its name starts
with a "t" and ends with a "t". It
is filled with "t". What is it?
Find the answer on the next
page.

 What day is today? Circle one.

 Sunday Monday Tuesday Wednesday Thursday Friday Saturday

Let's trace the answer.

It's the teapot.

Please rewrite the above answer in the following space.

How to draw a painting boy?
Let's trace.

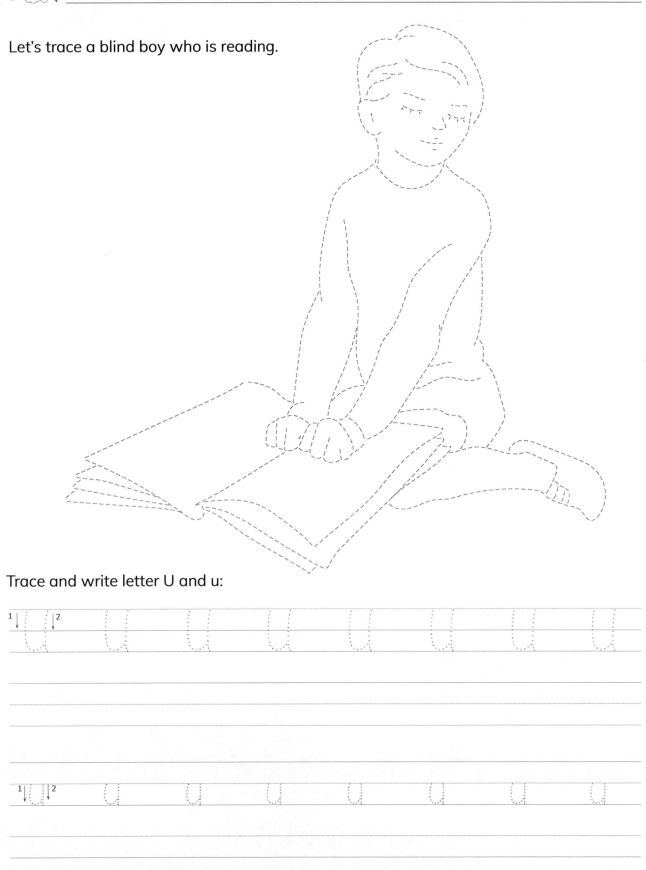

Write your name above the line.

Let's trace a blind boy who is reading.

Trace and write letter U and u:

1↓ 2↓ U U U U U U U U

1↓ U 2↓ u u u u u u u

64 § How to draw a blind boy who is reading?

 What day is today? Circle one.

 Sunday Monday Tuesday Wednesday Thursday Friday Saturday

Read In Dark

A boy was reading a book in a room. The room had no lamp, no candle and no light at all. How was that possible?

Find the answer on the next page.

Let's trace the riddle.

A boy was reading a book in a
room. The room had no lamp, no
candle and no light at all. How
was that possible?
Find the answer on the next
page.

 Write your name above the line.

Let's answer the Read In Dark. Please trace.

The boy was blind and reading
by hand.
 Braille is a language that
uses raised dots on embossed
paper and read by hand.

What is the "Love" in braille?

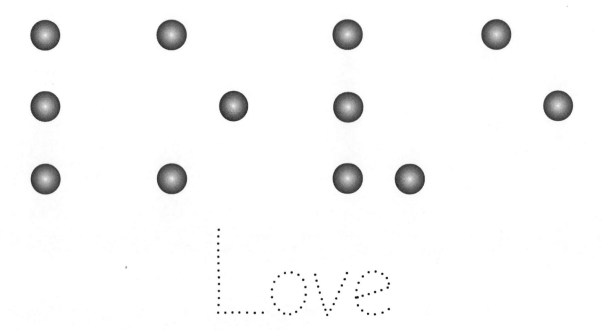

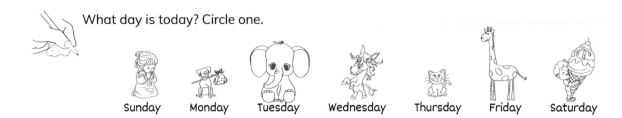

Sunday　Monday　Tuesday　Wednesday　Thursday　Friday　Saturday

How to draw a panda who knows kongfu? Let's trace.

Trace and write letter V and v:

 Write your name above the line.

The Name Of The Fourth Child

Ava's mother has four children. The first three of them are named, April, May and June. What's the name of the fourth child?

The answer is on the next page.

Let's trace the riddle.

Ava's mother has four
children. The first three of them
are named, April, May and June.
What's the name of the fourth
child?
The answer is on the next page.

 What day is today? Circle one.

Sunday Monday Tuesday Wednesday Thursday Friday Saturday

Let's trace the answer.

It's Ava.

Please rewrite the above answer in the following space.

How to draw a cow? Let's trace.

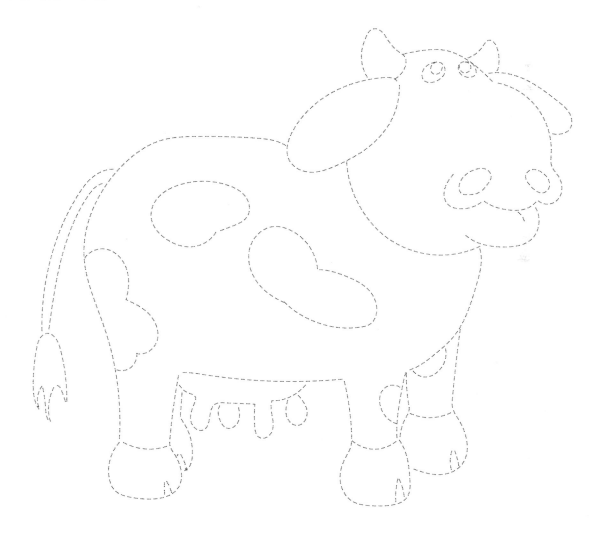

 Write your name above the line.

How to draw a blue whale, the biggest animal on Earth? Let's trace.

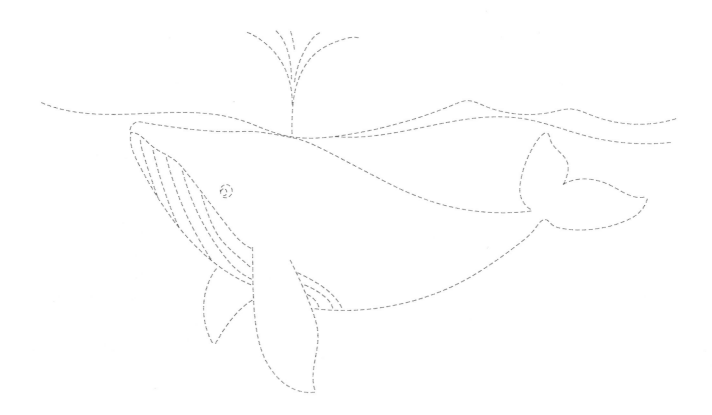

Trace and write letter W and w:

Trace and write letter W and w:

 What day is today? Circle one.

Sunday

Monday Tuesday

Wednesday

Thursday

Friday

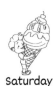
Saturday

What's Wrong?

What word spelled wrong in all the books?

Find the answer on the next page.

Think about the word "wrong".

Let's trace the riddle.

What word spelled wrong in all the books? Find the answer on the next page. Think about the word "wrong".

Write your name above the line.

Please trace the answer.

The answer is the word "wrong".
It is spelled wrong in all the
books.

Please rewrite the above answer in the following space.

Let's draw some fish.

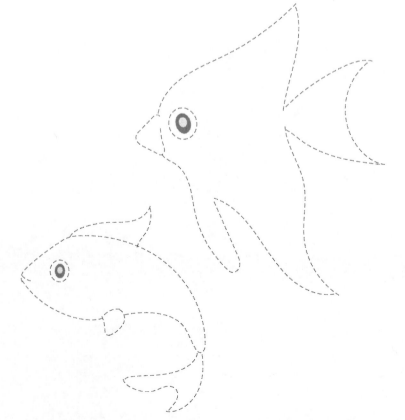

What day is today? Circle one.

Sunday Monday Tuesday Wednesday Thursday Friday Saturday

How to draw a mermaid? Let's trace.

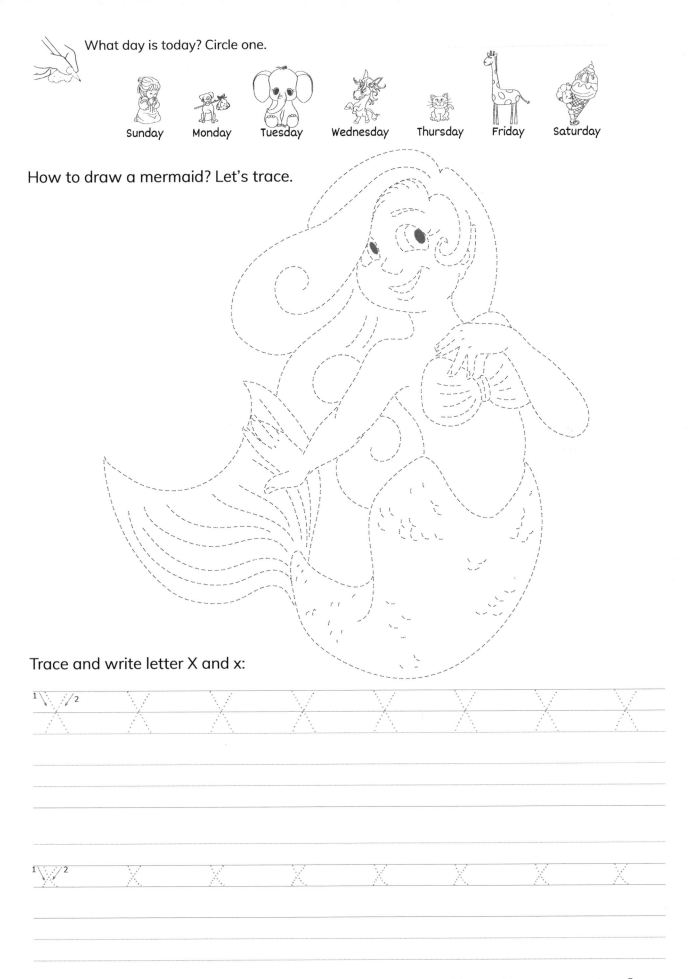

Trace and write letter X and x:

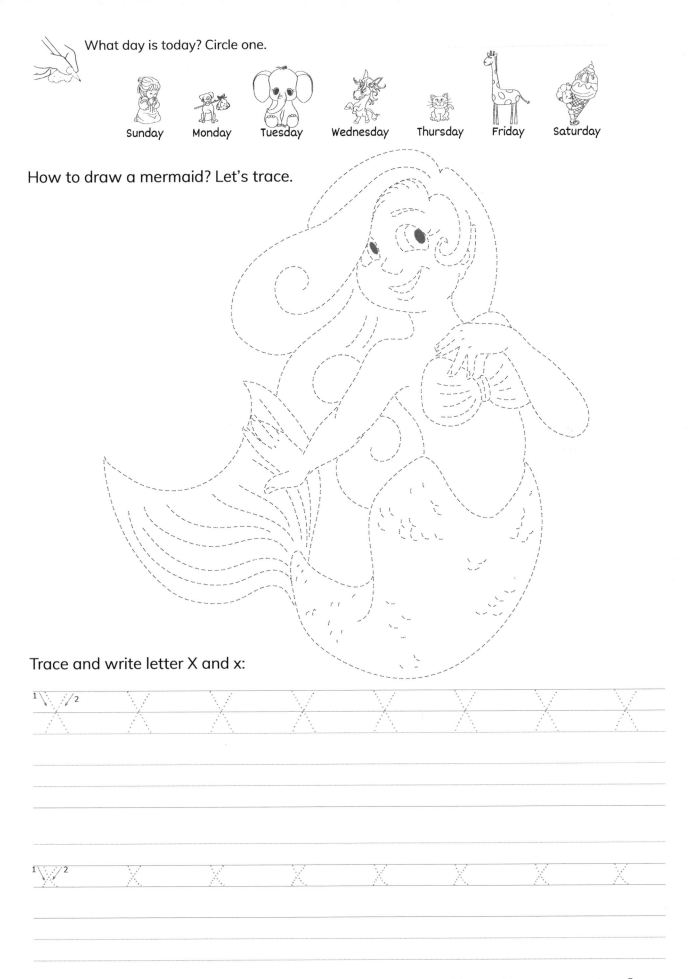

 Write your name above the line.

Wet Coat?

No one likes to put on wet clothes, right? It doesn't feel good. But can you think of a kind of coat that can only be put on when wet?

The answer is on the next page.

Let's trace the riddle.

No one likes to put on wet
clothes, right? It doesn't feel
good. But can you think of a kind of
coat that can only be put on when
wet?
The answer is on the next page.

What day is today? Circle one.

| Sunday | Monday | Tuesday | Wednesday | Thursday | Friday | Saturday |

Let's trace the answer.

It's the paint.

Please rewrite the above answer in the following space.

How to draw a rain coat? Let's trace.

 Write your name above the line.

How to draw a sponge? Let's trace.

Trace and write letter Y and y:

Y Y Y Y Y Y Y Y

y y y y y y y y

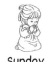
Sunday

Monday

Tuesday

Wednesday

Thursday

Friday

Saturday

Water In The Holes!

Can you think of a thing that has holes all over but still holds water?

Find the answer on the next page.

Let's trace the riddle.

Can you think of a thing that has holes all over but still holds water?

Find the answer on the next page.

 Write your name above the line.

Let's answer the riddle. Please trace.

The answer is sponge.
Sponges are good at absorbing
water and juice.

Please rewrite the above answer in the following space.

Let's draw watering.

What day is today? Circle one.

Sunday

Monday

Tuesday

Wednesday

Thursday

Friday

Saturday

How to raise a heavy stone? Let's trace.

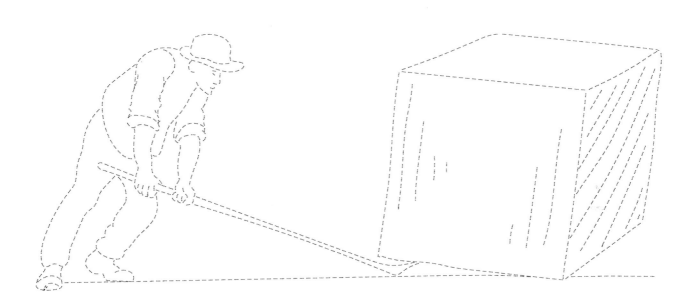

Trace and write letter Z and z:

 Write your name above the line.

Let's trace the question.

Can you move the earth?

Please write the above question in the following space.

Let's trace a powerful baby.

 What day is today? Circle one.

 Sunday

 Monday

Tuesday

 Wednesday

 Thursday

 Friday

 Saturday

Move the Earth

Let's trace a quote.

Give me the place to stand, and I shall move the earth.

— Archimedes

Please rewrite the above famous quote in the following space.

Write your name above the line.

What's a pangram?

There are 26 letters in the English alphabet. Can you find all of them in the following sentence?

The quick brown fox jumps over the lazy dog.

THE QUICK BROWN FOX JUMPS OVER THE LAZY DOG.

Do you find all the 26 letters? Circle the answer.

Yes No

A pangram is a sentence using every letter of the alphabet at least once.

 What day is today? Circle one.

 Sunday
 Monday
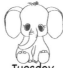 Tuesday
Wednesday
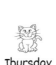 Thursday
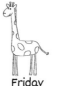 Friday
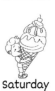 Saturday

This font is neat:

The quick brown fox jumps over the lazy dog.

THE QUICK BROWN FOX JUMPS OVER THE LAZY DOG.

This font can dance:

The quick brown fox jumps over the lazy dog.

THE QUICK BROWN FOX JUMPS OVER THE LAZY DOG.

Let's dance your pencil on the paper:

The quick brown fox jumps over
the lazy dog.

 Write your name above the line.

A pangram written with the Neat font:

The five boxing wizards jump quickly.

A pangram written with the Dance font:

The five boxing wizards jump quickly.

Do you find all the 26 letters in the above pangram? How many letters in the sentence? Circle the answer.

29 30 31 32 33

Let's dance your pencil on the paper:

The five boxing wizards jump
quickly.

 What day is today? Circle one.

 Sunday Monday Tuesday Wednesday Thursday Friday Saturday

Trace the excited cat:

Let's start the Dance font!

Ah-Ha! Let's start to Dance!

Trace and write letter A and a.

A A A A A A

Â Â Â Â Â Â

 Write your name above the line.

Why did Jacob eat his homework?

 The answer is on the next page.

Let's trace the riddle.

Why did Jacob eat his

homework?

The answer is on the

next page.

§ A piece of cake!

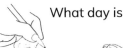 **What day is today? Circle one.**

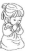 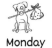 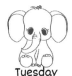

Sunday Monday Tuesday Wednesday Thursday Friday Saturday

Because the teacher told Jacob it was a piece of cake!

Trace and write letter B and b.

Let's draw a happy bird.

Write your name above the line.

What's the cow making when she jumps up and down?

The answer is on the next page.

Let's trace the riddle.

What's the cow making
when she jumps up and
down?
The answer is on the
next page.

 What day is today? Circle one.

Sunday Monday Tuesday Wednesday Thursday Friday Saturday

Milkshake.

Trace and write letter C and c.

Let's draw a happy cow.

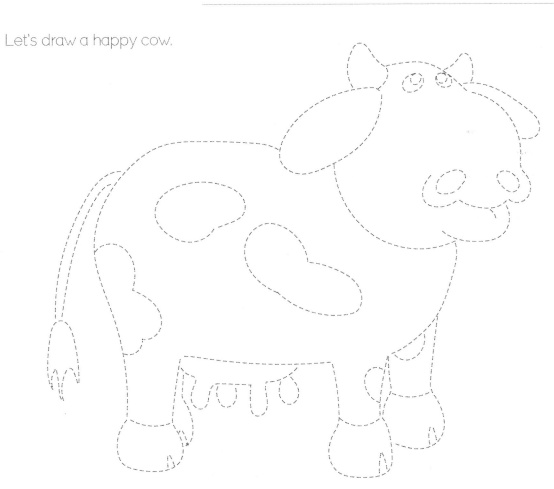

 Write your name above the line.

What else can we put on this delicious
birthday cake?

Let's trace the riddle.

What else can we put on
this delicious birthday?

 What day is today? Circle one.

 Sunday Monday Tuesday Wednesday Thursday Friday Saturday

My mouth.

Trace and write letter D and d.

Let's draw a mad dog.

 Write your name above the line.

Why shouldn't you tell an egg funny
stories?

Let's trace the riddle.

Why shouldn't you tell
an egg funny stories?

 What day is today? Circle one.

Sunday

Monday

Tuesday

Wednesday

Thursday

Friday

Saturday

It might
crack up!

Trace and write letter E and e.

Let's draw a confused elephant.

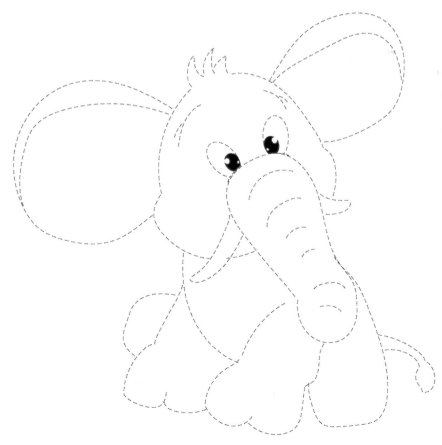

Confused elephant. § 93

 Write your name above the line.

Samantha's mother has four daughters.
She named the first three daughters April,
May, and June. What's the name of the
forth?

Let's trace the riddle.

Samantha's mother has

four daughters. She named

the first three daughters

April, May, and June.

What's the name of the

forth?

 What day is today? Circle one.

 Sunday Monday Tuesday Wednesday Thursday Friday Saturday

Samantha

Trace and write letter F and f.

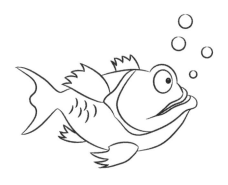

Let's draw a big mouth fish.

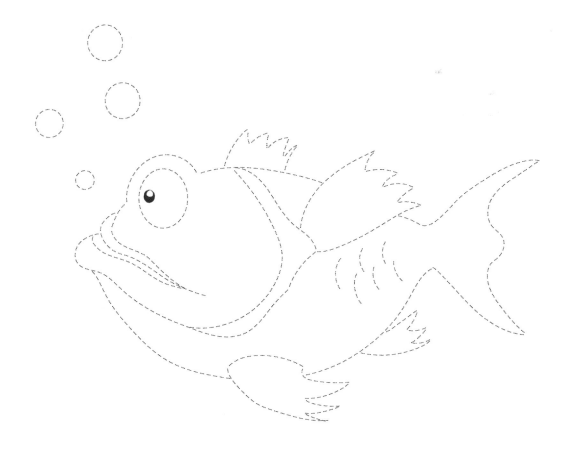

Big mouth fish § 95

 Write your name above the line.

What's the word spelled wrong in all books?

Let's trace the riddle.

What's the word spelled wrong in all books?

§ Mom and baby giraffes.

 What day is today? Circle one.

Sunday Monday Tuesday Wednesday Thursday Friday Saturday

The word wrong.

Trace and write letter G and g.

G G G G G G

g g g g g g

Let's draw mom and baby giraffes.

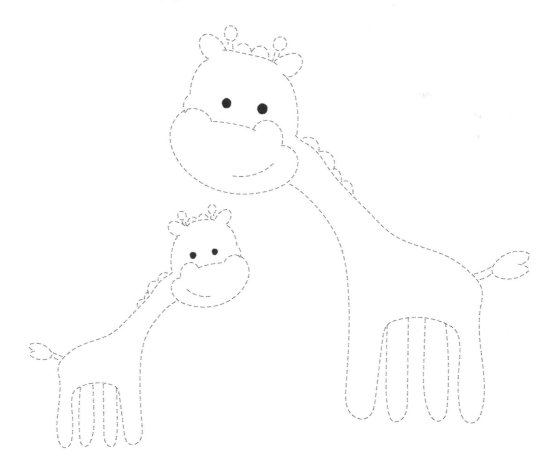

Mom and baby giraffes. § 97

 Write your name above the line.

What can you break by simply saying it?

Let's trace the riddle.

What can you break by
simply saying it?

§ Draw a horse

What day is today? Circle one.

Sunday

Monday

Tuesday

Wednesday

Thursday

Friday

Saturday

The silence.

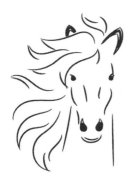

Let's draw a horse.

Trace and write letter H and h.

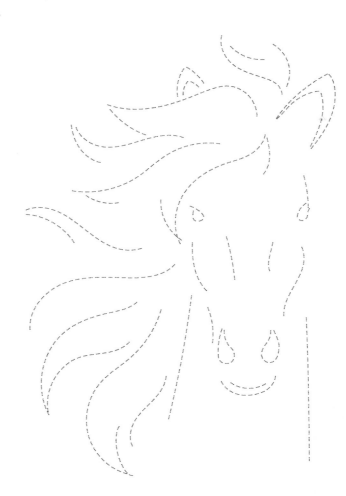

 Write your name above the line.

What's an alligator in the vest?

Trace the riddle and write your anwer in the extra space.

What's an alligator in
the vest?

§ Draw deer

 What day is today? Circle one.

 Sunday Monday Tuesday Wednesday Thursday Friday Saturday

Trace and write letter I and i.

Investigator.

Let's draw deer.

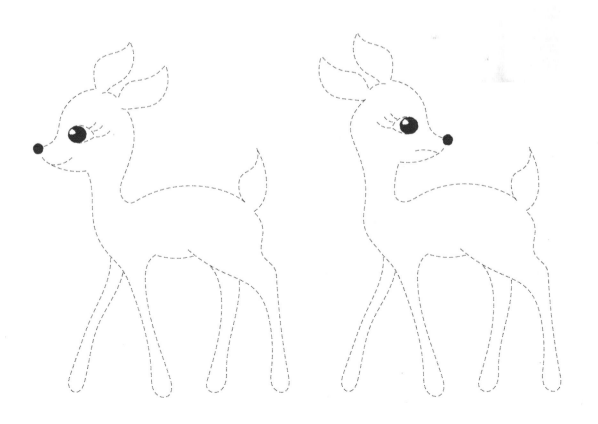

Write your name above the line.

What is greater than God, eviler than
the devil, the poor have it, the rich need it,
and if you eat it you'll die?

Trace the riddle and write your anwer in the extra space.

§ A dachshund

What day is today? Circle one.

Sunday Monday Tuesday Wednesday Thursday Friday Saturday

Trace and write letter J and j.

Nothing.

J J J J J J

j j j j j j

Let's draw a dachshund.

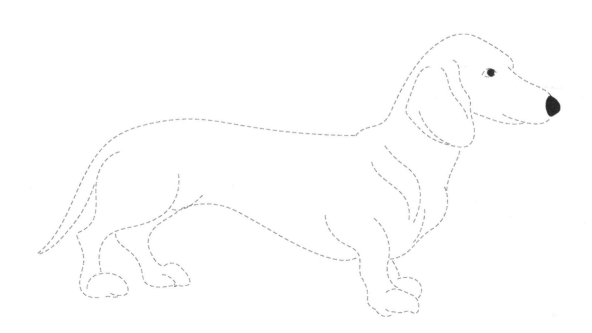

 Write your name above the line.

What's full of holes but still holds
water?

Trace the riddle and write your anwer in the extra space.

What's full of holes but
still holds water?

§ A cat chasing a toy mouse.

 What day is today? Circle one.

 Sunday Monday Tuesday Wednesday Thursday Friday Saturday

Trace and write letter K and k.

A sponge

Let's draw a cat chasing a toy mouse.

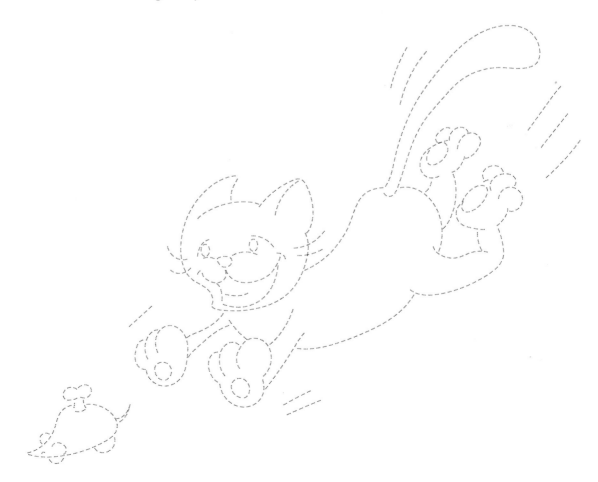

A cat chasing a toy mouse. § 105

 Write your name above the line.

What belongs to you but other people use it more than you do?

Trace the riddle and write your anwer in the extra space.

What belongs to you

but other people use it

more than you do?

What day is today? Circle one.

Sunday Monday Tuesday Wednesday Thursday Friday Saturday

Trace and write letter L and l.

Your name.

Let's draw an angry bull.

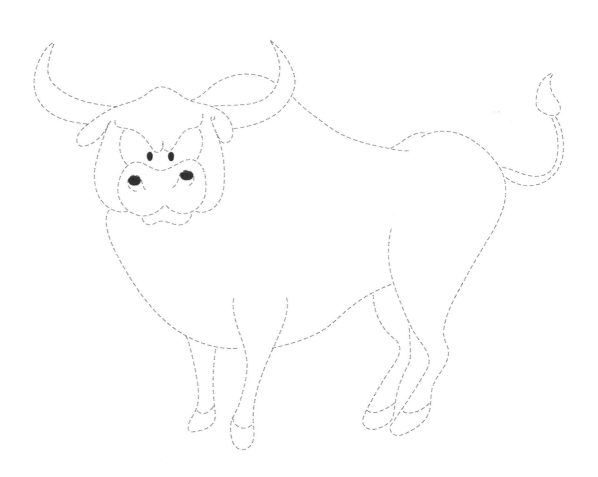

An angry bull § 107

Write your name above the line.

What a five-letter word becomes shorter
if you add two letters to it?

Trace the riddle and write your anwer in the extra space.

What a five-letter word
becomes shorter if you add
two letters to it?

What day is today? Circle one.

 Sunday

Monday

 Tuesday

 Wednesday

 Thursday

Friday

 Saturday

Short

Trace and write letter M and m.

M M M M M M M

m m m m m m

Let's draw a cat holding an umbrella.

A cat in the rain § 109

 Write your name above the line.

What was the highest mountain in the
world before Mount Everest was discovered?

Trace the riddle and write your anwer in the extra space.

What was the highest

mountain in the world

before Mount Everest was

discovered?

§ A hungry cat looking at a fish

 What day is today? Circle one.

 Sunday Monday Tuesday Wednesday Thursday Friday Saturday

Mount Everest

Trace and write letter N and n.

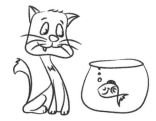

Let's draw a hungry cat looking at a fish.

A hungry cat looking at a fish § 111

 Write your name above the line.

Jenny throws a ball as hard as she can but It comes back to her, even nothing and nobody touches the ball. Why?

Trace the riddle and write your anwer in the extra space.

Jenny throws a ball as
hard as she can but It
comes back to her, even
nothing and nobody touches
the ball. Why?

§ A big mouth hippo

 What day is today? Circle one.

Sunday Monday Tuesday Wednesday Thursday Friday Saturday

She throws it straight up.

Trace and write letter O and o.

O O O O O O

o o o o o o

Let's draw a big mouth hippo.

A big mouth hippo § 113

 Write your name above the line.

Jimmy's father has one daughter and two sons Pretty, Handsome and who?

Trace the riddle and write your anwer in the extra space.

Jimmy's father has one

daughter and two sons

Pretty, handsome and who?

 What day is today? Circle one.

 Sunday Monday Tuesday Wednesday Thursday Friday Saturday

Trace and write letter P and p.

Jimmy

P P P P P P

p p p p p p

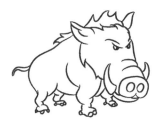

Let's draw a angry hog.

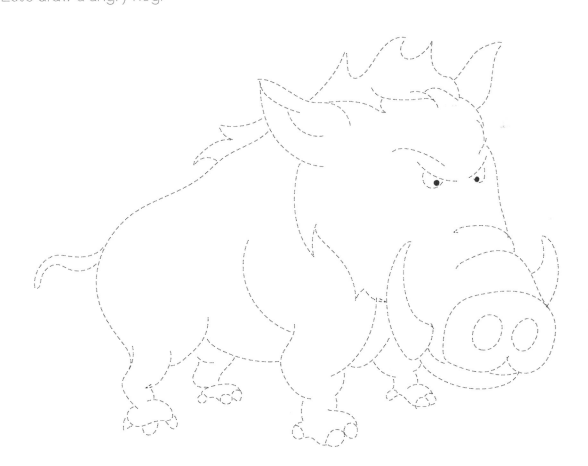

An angry hog § 115

Write your name above the line.

Why are teddy bears never hungry?

Trace the riddle and write your anwer in the extra space.

Why are teddy bears

never hungry?

What day is today? Circle one.

Sunday Monday Tuesday Wednesday Thursday Friday Saturday

They are stuffed

Trace and write letter Q and q.

Q Q Q Q Q Q

q q q q q q

Let's draw rabbits.

Rabbits § 117

 Write your name above the line.

What is the easiest way to double your money?

Trace the riddle and write your anwer in the extra space.

What is the easiest way
to double your money?

§ Draw a hot dog

 What day is today? Circle one.

 Sunday Monday Tuesday Wednesday Thursday Friday Saturday

Put it in front
of a mirror

Trace and write letter R and r.

Let's draw a hot dog.

Write your name above the line.

What is as big as an elephant, but weighs nothing at all?

Trace the riddle and write your anwer in the extra space.

What is as big as an
elephant, but weighs nothing
at all?

§ A boy with big teeth

What day is today? Circle one.

 Sunday
Monday
 Tuesday
Wednesday
 Thursday
 Friday
Saturday

The elephant's shadow.

A boy with big teeth

Trace and write letter S and s.

S S S S S S

s s s s s s

Write your name above the line.

Which football player wears the biggest helmet?

Trace the riddle and write your anwer in the extra space.

Which football player

wears the biggest helmet?

 What day is today? Circle one.

Sunday Monday Tuesday Wednesday Thursday Friday Saturday

The one with the biggest head in the team.

Trace and write letter T and t.

T T T T T T

t t t t t t

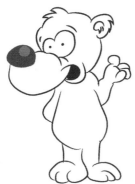

A talking dog.

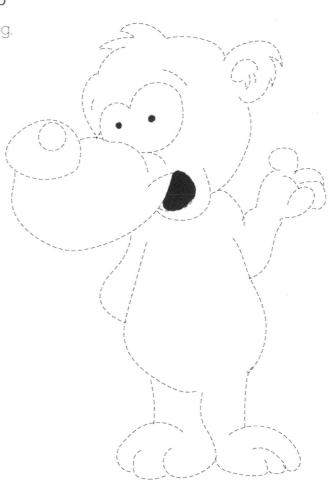

A talking dog § 123

 Write your name above the line.

A thing has head and tail but no body,
what is it?

Trace the riddle and write your anwer in the extra space.

A thing has head and tail
but no body, what is it?

 What day is today? Circle one.

Sunday Monday Tuesday Wednesday Thursday Friday Saturday

Coin.

Trace and write letter U and u.

Let's draw girl.

 Write your name above the line.

What lets you look right through a wall?

Trace the riddle and write your anwer in the extra space.

What lets you look
right through a wall?

 What day is today? Circle one.

Sunday Monday Tuesday Wednesday Thursday Friday Saturday

Trace and write letter V and v.

Windows

Let's draw a boy.

 Write your name above the line.

What goes up when rain comes down?

Trace the riddle and write your anwer in the extra space.

What goes up when rain

comes down?

 What day is today? Circle one.

Sunday Monday Tuesday Wednesday Thursday Friday Saturday

Trace and write letter W and w.

Umbrella

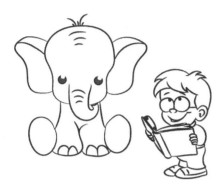

Let's draw a boy who is reading for his baby elephant.

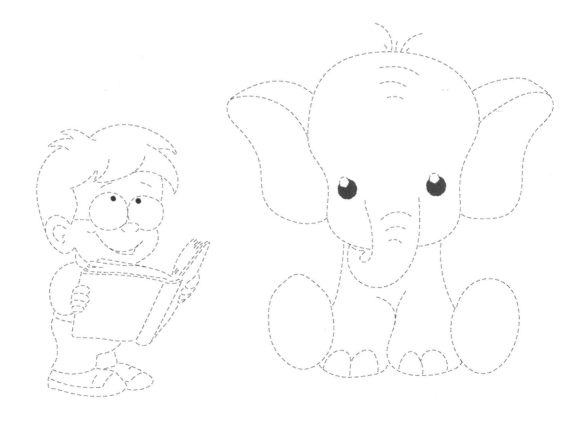

 Write your name above the line.

There is a word. If you pronounce it right, it's wrong. If you pronounce it wrong, it's right. What word is it?

Trace the riddle and write your anwer in the extra space.

There is a word. If you
pronounce it right, it's
wrong. If you pronounce it
wrong, it's right. What
word is it?

 What day is today? Circle one.

Sunday

Monday

Tuesday

Wednesday

Thursday

Friday

Saturday

Trace and write letter X and x.

Wrong.

Let's draw a beast.

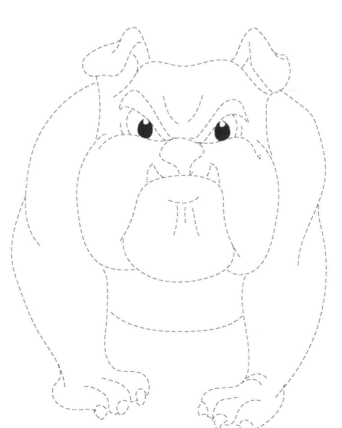

 Write your name above the line.

A thing loses it's head every morning, but get it back at night. What is it?

Trace the riddle and write your anwer in the extra space.

§ Draw a model

 What day is today? Circle one.

Sunday Monday Tuesday Wednesday Thursday Friday Saturday

Trace and write letter Y and y.

A pillow

Let's draw a model.

 Write your name above the line.

Samantha's mom has seven daughters and each daughter has a brother. How many children does Samantha's mom have all together?

Trace the riddle and write your anwer in the extra space.

Samantha's mom has seven

daughters and each daughter

has a brother. How many

children does Samantha's mom

have all together?

Sunday

Monday

Tuesday

Wednesday

Thursday

Friday

Saturday

Trace and write letter Z and z.

Eight

Let's draw good friends.

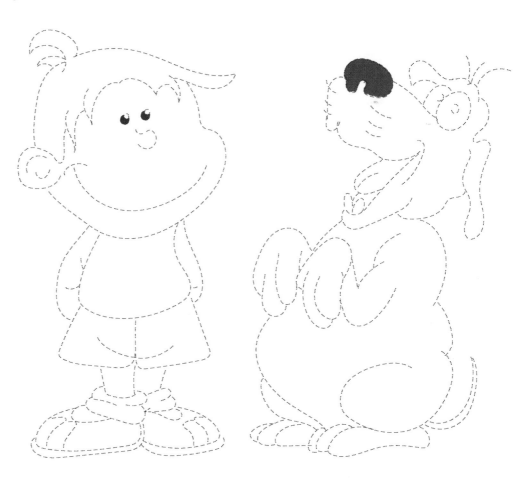

Write your name above the line.

Sunday Monday Tuesday Wednesday Thursday Friday Saturday

Printed in Great Britain
by Amazon